HAUNTED HILLS

HAUNTED HILLS

GHOSTS AND LEGENDS OF HIGHLANDS AND CASHIERS NORTH CAROLINA

STEPHANIE BURT WILLIAMS

Haunted America

Published by Haunted America
A Division of The History Press
Charleston, SC 29403
www.historypress.net

Front cover: photo by the author.
Back cover: High Hampton Inn at night. *Photo courtesy of the High Hampton Inn.*
Author photo by Karyn Iserman.

First published 2007
Second printing 2008

Manufactured in the United States

ISBN 978.1.59629.257.4

Library of Congress Cataloging-in-Publication Data

Williams, Stephanie Burt.
 Haunted hills : ghosts and legends of Highlands and Cashiers, North Carolina
/ Stephanie Burt Williams.
 p. cm.
 ISBN 978-1-59629-257-4 (alk. paper)
 1. Ghosts--North Carolina. 2. Haunted places--North Carolina. 3.
Legends--North Carolina. I. Title.
 BF1472.U6W555 2007
 133.109756'95--dc22
 2007026828

Notice: The information in this book is true and complete to the best of our knowledge. It is offered without guarantee on the part of the author or The History Press. The author and The History Press disclaim all liability in connection with the use of this book.

For Bob, my hiking partner to the bottom of Rainbow Falls and back out again

CONTENTS

CONTENTS

Acknowledgements

Thanks first to Melody Spurney, managing editor of *The Highlander*, whose encouragement and enthusiasm for my series of ghost stories (while a staff writer) got this whole thing rolling. Thanks also to Ran Shaffner, not only for his quintessential history of Highlands, but also for his immense dedication to archiving Highlands's visual history through the photography collection of the Highlands Historical Society. Rhonda Gray Alexander at the Cashiers General Store was my Cashiers "connection" and provided me with a wealth of information and many contacts. And thanks most of all to my family and friends for their encouragement and patience throughout this project.

INTRODUCTION

It is easy to understand how the North Carolina mountains hold secrets. There may be a waterfall around a bend, hidden deep in a pocket of rhododendron on the curve of a rocky path. Deep foliage can reveal a mossy garden in a glade with a single glance, and a bear and her family may inexplicably show up on your front lawn, frolicking under the birdfeeder. In short, it is a place that does not reveal itself all at once.

The towns of Highlands and Cashiers are deep in these mountains; they are not in the foothills where the hills are rolling and the roads are often wide. The roads here often have serious switchbacks that require drivers to slow down and notice the precarious nature of their journeys. In fact, there are no superhighways with Highlands or Cashiers as an exit (complete with a fast-food joint and a mega gas station). No, Highlands and Cashiers are about the quieter life, about vacations and escape from the everyday hustle and bustle of the cities.

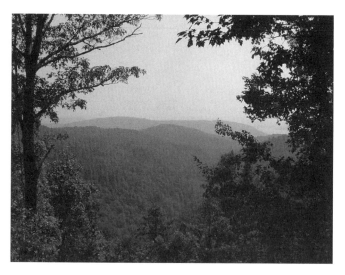

The Highlands-Cashiers area is rich in folklore—and breathtaking views such as this one. *Photo by the author.*

The towns are full of the sounds of rushing water, of cool night breezes with the windows open and of a golf ball hitting a green.

Deep in these places are whispered the stories that need to be passed down. They are tales of magic, of the unexplained and of violence that traps souls still trying to make contact today. These are those stories.

Highlands

There is a legend about the founding of Highlands. It is said that two developers took a map and drew a line from New York City to New Orleans, then drew another line between Chicago and Savannah. They saw these routes as the great trade routes of the future, and of course where they crossed on the map would be a great population center, full of commerce and bustling activity. So they set out to settle that crossroads where the two lines met. It was Highlands, sitting high on a mountain plateau, with an elevation of 4,118 feet.

Obviously, Highlands never became the commercial center for which the pioneers had hoped. Anchored by a few blocks of Main Street, Highlands spreads out in residential communities and country clubs east toward Cashiers, west toward Franklin and south toward Rabun County, Georgia. But it has always remained mostly a seasonal town, with summers bringing well-

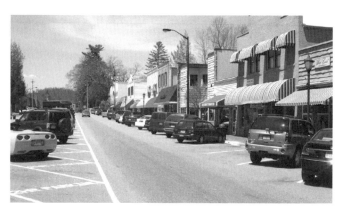

Looking west on Main Street in Highlands. *Photo courtesy of the* Highlander.

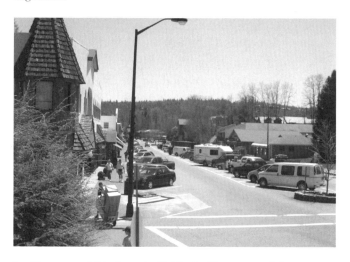

Looking east on Main Street in Highlands. *Photo courtesy of the* Highlander.

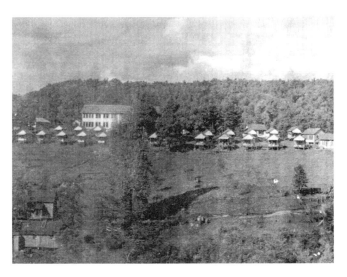

Highlands Sanatorium, or "Bug Hill," was a social and medical center in Highlands. All the little buildings situated in rows on the hill are the open-air "tents" for tuberculosis patients. *Photo circa 1910, courtesy of the Highlands Historical Society.*

heeled tourists from Atlanta and the winter left to the roughly nine hundred residents who call it home year-round.

Despite its small size, it has always been a destination in the southwest North Carolina mountains. Dr. Mary Lapham, noted for her Swiss therapy for tuberculosis, opened Highlands Sanatorium, which soon became a social center and employer for many people in the town. "Bug Hill," as it became commonly known,

brought people from Atlanta, Asheville, Savannah and Charleston for a cure through crisp mountain air and a variety of tuberculosis treatments.

It next became a destination for golf when a new golf course in Highlands became a practice course for legendary golfer Bobby Jones. Construction of courses expanded as the game's popularity increased, and today golfing is a large part of Highlands culture.

Highlands's modern era has seen a juxtaposition of the old and new. High-boutique shops and a lavish spa share the same street with a pharmacy that still has a lunch counter and an old inn that does not have central heating. Old buildings sit next to new ones, and hikers, shoppers and mountain folk mix on the same street.

Kalalanta
The Sea Captain Likes the View

It's a myth that all sea captains long for the sea. Some long for the mountains.

Kalalanta, named after the Cherokee word for "high place" or "heaven," is a stately home on Bowery Road, a road that, although only a few blocks from the town center, is unpaved and quite winding. And its residents like it that way, fighting to keep their road unpaved. As one of the oldest residential streets in Highlands, its unpaved quality is part of what residents consider its "historic character."

Kalalanta is a tall clapboard home that is situated on a lush lawn among rhododendron and hemlock. It stands tall over an impressive view of Horse Cove below and the South Carolina mountains beyond. It is one of many homes on Bowery Road filled with vacationers during the high tourist season.

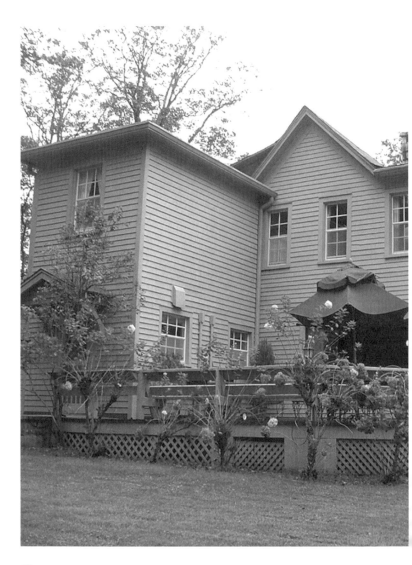

Kalalanta sits on a beautiful property that has long-range mountain views. *Photo by the author, courtesy of the* Highlander.

Mrs. K.T. Bingham, a naval officer's wife, originally built the home in 1883. It was sold a year later to the Ravenels, who used it as a sort of guesthouse, and eventually it passed to its current owner, Joanne Fleming, who has owned it for more than forty years.

As any vacation home with a storied past, there have been many times over the years when it sat vacant on the winding dirt road high above verdant Horse Cove. Although its bustling vacationers lent a celebratory air to the place, the dark windows and quiet lawn excited Highlanders' imaginations even more. Historian Ran Shaffner details Kalalanta in his book, *Heart of the Blue Ridge*:

> *During periods when it was deserted, Kalalanta was said to be haunted, mysterious things having been heard or seen there. No child in Highlands dared venture anywhere near it after nightfall, and children gathering chestnuts during the day gave it an especially wide berth. On one occasion, however, Bud and John Hall and a few other young friends led a group of girls staying at the Hall house to Bowery Ridge, and draping themselves in sheets brought the ghosts of Kalalanta to life so effectively that one young lady fainted dead away and had to be revived.*

But people in sheets don't create the footsteps that pace the upstairs floor or rocking chairs that rock with no people in them or wind moving them. It seems the children might have had something to be afraid of.

"This house was completely renovated in 1929, and in spite of that, when I would sit down here in the living room, I could sometimes hear someone walking the floor above me," said Fleming, its current owner.

She said it was a clear sound, a sort of pacing back and forth, and that the mysterious footsteps never went down the stairs or into any other part of the house. But other things have occurred, if not footsteps. "We've been here for many years, and we have seen the rocking chairs out on the porch rock numerous times with no one in them," she recalled. "There was not a breeze, and we have seen them mostly through the window, but I am sure that we have been out there when they were rocking, too. My family used to spend a lot of time out there on the porch."

From that porch Kalalanta has a breathtaking view, even on a gloomy day, of Fodderstack Mountain, Rich Mountain and the lights of Spartanburg and Walhalla, South Carolina, at night. Wooden rocking chairs sit invitingly on the porch, comfortable cushions propped leisurely in them. They seem harmless, normal and familiar. And yet, inexplicably, on random afternoons,

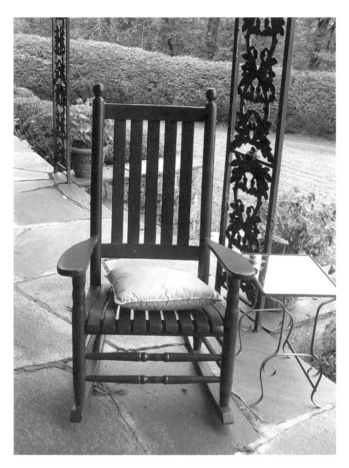

Guests and residents of Kalalanta have witnessed rocking chairs rocking of their own accord without a breeze. *Photo by the author, courtesy of the* Highlander.

just when the late sun begins to slip beneath the tree line, they will start to rock.

"We have always loved it here, the peace and quiet, the view from the house," Fleming said.

Her family has indeed enjoyed the home, so much so that they often have invited friends up for long weekends or extended stays.

"One couple woke up one morning and came downstairs to find an apparition sitting on the couch. It was a man with a beard and a pipe, and so we always called him the sea captain," she said. She never mentioned if those visitors decided to make the trip to Kalalanta again, to breathe in its views of the mountains and share the home with apparitions who enjoy that view as well.

The same couch still sits in that room, long and lean and pushed up against the wall. From the couch, one can see the same view of the mountains that the porch allows, so maybe the sea captain was just tired of sitting in a rocking chair—or maybe tired of pacing the floor.

Nevertheless, Fleming has never personally seen him, and she said he has seemed quiet over the past few years.

"But every once in a while, those rocking chairs will still rock," she says.

Gray Cottage
Little "Old-Fashioned" Boy

Highlands's Main Street is picturesque, no doubt. The business district at the heart of downtown has been photographed by countless tourists, and many of the oldest buildings in town sit on either side of it. Nestled in between a woodworker's studio and a kitchen shop is Wolfgang's on Main, one of the most acclaimed restaurants in the tiny town, known for its wine selection and great atmosphere.

Diners happily make reservations to come to the restaurant nightly and enjoy dishes such as the Brandied Half Roast Duckling or the Veal Medallions Wolfgang. Part of Wolfgang's "mystique" is its charming setting, great food in a wonderful old house with fireplaces and warm wood ceilings that make the guests feel as if they are having a unique experience. And they might be, more than they know, if they happen to see a little boy run through the room and disappear.

As is the case with many restaurants in historic locations, the building that houses Wolfgang's was not originally built as a restaurant. In fact, it was one of the first and most famous of Highlands's houses, named the Gray Cottage and built in 1883 by Joseph A. McGuire for Miss Mary Chapin, three years before she married John Jay Smith.

Mary Chapin Smith was a star in Highlands's early history. She was instrumental in setting up and contributing to the Highlands Library, and Shaffner writes that "at the time of her death in 1940, [and] her husband's passing a year later, her civic contributions to the town during almost sixty years were valued as indispensable. Friends praised her for her keen interest in the civic welfare and beauty of the town to the extent that her passing was a tragic loss to the people of Highlands."

John Jay, her husband, served as Highlands's mayor for two non-consecutive terms, 1888–1889 and many years later from 1925 to 1927. Although he was remembered as a wonderful person, he was not an especially astute businessman, but a better friend and woodworker. However, he gave the region the Dillard Road, laying it out between 1904 and 1906, and for a long time it was known as Smith's Road. Today that road is Highway 106.

At the Gray Cottage, Mary created a personal garden that emulated the Anne Hathaway Garden

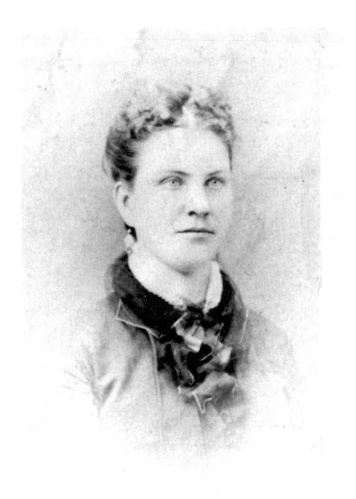

Mary Chapin Smith was a much beloved member of early Highlands and contributed to the town throughout her life. *Photo circa 1890, courtesy of the Highlands Historical Society.*

in England, and she evidently loved the home as it was her only residence once she moved to Highlands until her death. Today, Wolfgang's has constructed a garden deck in that once personal garden, but its setting is ideal for a romantic candlelight dinner on a cool summer evening. Wonderful landscaping is still a feature of the home, and from the back view, it's easy to see that the structure was once a comfortable home for the couple.

After the Smiths' deaths, the house passed through several hands. It is unknown whether the Smiths had a son who did not reach adulthood, but that is the story of the Gray Cottage ghost.

The town legend is that a boy died young in the house of a fever or illness. Sadly, child mortality was high until the middle 1900s, so this fact in itself does not seem all that unlikely. It is this spirit who is said to haunt the restaurant today, the apparition of a little boy whom the staff reports seeing in the dining room, upstairs in some living quarters and even once in the kitchen, shocking the staff as they were preparing for the evening.

He doesn't really do anything, just walks or runs through the room, and his appearance is brief and surprising. Some say that he is dressed in "old-fashioned clothes" or seems "old-fashioned." Although the staff and patrons don't see him very often, they do report

unusual cold spots, even on days when the fireplaces are filled with crackling fires and the kitchen is in full swing with the evening shift.

But one incident seems to be the most profound, in that it follows the pattern that many ghost stories take. If you read or hear enough ghost stories, you will realize a major element in the storytelling—ghosts like to manipulate things, especially water or electronics. Often people will report that the first sign they noticed indicating that their house was haunted was the fact that the bathtub spigot would turn on when no one was in the room. Even more people report ghosts messing with electronic equipment.

Above Wolfgang's is a former living apartment that now serves as an office and break area for employees. One such employee had an unusual experience here. He walked downstairs after turning off the television and started setting the tables for dinner. After coming back in the room that was directly under the television set, he could hear the faint noise of the TV floating through the ceiling. Of course he investigated and realized that the television was on again, even though he distinctly remembered turning it off. There was also a cold breeze in the room. Maybe a little boy was interested in getting someone's attention, a little boy who never got the chance to grow up.

ED "BENNIE" ROGERS AND EARLY HIGHLANDS LAW ENFORCEMENT
Larger Than Life

Highlands was a small town—still is—but before the middle of the twentieth century, it was a very small town. The highest town east of the Rockies, Highlands was part of the Appalachian frontier, where few families lived year-round, and the population swelled in the summer months with vacationers from Atlanta who would arrive to escape the oppressive Southern summers. Highlands provided a lush escape for these droves of visitors.

But this story is not about those summer tourists or the grand homes they inhabited—it is about day-to-day life in Highlands away from the genteel life of rich vacationers. It is about bootleg whiskey, fistfights and the struggle to build a town in such a remote area.

A central figure in all of this is Ed "Bennie" Rogers, who was the entire police force from 1912 or 1913 until Old Dryman succeeded him as chief. Why is there no

exact date on when he became "the law"? Well, Rogers didn't want the job.

From all accounts, Rogers cut an imposing figure in the town. One of his hands was as big as two of a normal sized man, and he had a personality to boot. With a squinty stare that said he knew what was *really* going on in Highlands, he was known for fighting, running moonshine and general meanness. In fact, he was known at the time of his appointment as the meanest man in town. Shaffner quotes Olin Dryman, Rogers's successor, as saying that

> *old man Davis was mayor when Bennie got hired. And they didn't have no po'lice, and they decided they'd hire Ed Rogers, meanest man in Highlands at that time. And they said if we can't do nothing with him, we'll just make po'lice out of him. So old man Davis met him on the street next morning, and he said, "Well, Bennie, we've hired your po'lice in Highlands."*
>
> *Bennie said, "The hell you have."*
>
> *Yeah, and he just pinned the badge up on 'im and said, "Now you're our po'lice." Bennie would scrap you, boy, I'm telling you, he was a rough 'un.*

Just because Rogers was now the law did not mean that he left all his wild days behind him and became a friendly small-town police chief. Rogers

Moonshine stills such as this one (depicted on an old postcard) were a familiar sight to many early Highlanders. *Image Courtesy of James Larkin Pearson Library Collection, Wilkes Community College.*

was no Andy Griffith. The lines between law-abiding citizen and criminal were blurred during Rogers's long tenure as police chief. Most of the town's shadier side revolved around alcohol, namely the drinking of it, the manufacture of it and the transportation of it.

As was the case in much of the South, moonshine or bootleg whiskey was a major addition to the local economy, which was more often than not built on subsistence farming. Making and selling whiskey added much-needed income to many families, and the ingredients of corn and sugar were easy and plentiful. The stills around Highlands produced the traditional

corn mash whiskey, but the region was also known for producing a special sugar whiskey, distilled from only sugar.

In 1945, at the end of his tenure as police chief, Rogers revealed some of his true "police work" to Dryman. Shaffner once again quotes Dryman in a story about the infamous Rogers:

> He told of a fifty- or sixty-gallon still he captured around 1945, which he took to the jail… "We caught it back over here on Middle Creek, took Rob [Lamb] up there and put him in the jail; Rob's the only one we caught." Bennie, who was turning his job over to Olin at that time, accompanied Rob back to Highlands.
>
> "Well," Olin complained, "Bennie got half a gallon of liquor and left, and he's supposed to come back after me. There's a forty-four barrels of mash there, and I's a busting the barrels, cutting the staves out of 'um. The still held ninety gallons. You could stand up in the pot, and your head wouldn't go out the cap on top.
>
> Well, I sat there till 'bout midnight, and nobody come after me. And finally my brother came, Hugh come and got me. We loaded up the whiskey, sugar, copper, and the still and everything and brought it up there and put it in jail, that old jail down in the laurel thicket.
>
> Luke Rice was on the town board at that time, Old man Luke. Him and two or three more. The jail had

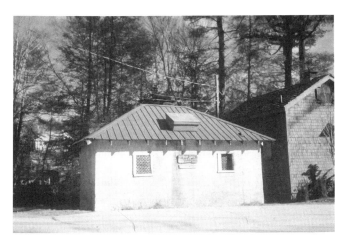

The Old Jail. *Photo by the author.*

> *holes through the windows you could put a hose pipe through, and they ciphered all the whiskey out and got away with it. And then they took a funnel and pour about five or six hundred pounds of sugar out of there and got away with that too, most of it. Old man Luke did that. I just had the empty can sitting there in the still the next morning. Bennie was into it, I guess, helped get the stuff out.*

So not only did Rogers assist in getting the liquor out, he also assisted in getting all that sugar out so it could again be earmarked as an ingredient for the whiskey. Bootleggers knew that they often had to pay a fee to

Ed "Bennie" Rogers was the only law in Highlands for years. *Photo circa 1952 from Pearle Rogers Lambert, courtesy of the Highlands Historical Society.*

the police to keep them away, and many bootleggers in Highlands had a special price on their product for the police (which, remember, was only one man, either Rogers or Dryman, for more than seventy years). Both police chiefs had seriously practiced bootlegging during their youth, so it only makes sense that they would retain a taste for the stuff and the money it provided.

Even as Rogers aged, he didn't seem to lose his meanness, or his suspicion of other people. Shaffner writes,

In 1945 Bennie had his leg taken off and had to quit the police force. Marshall Reese says he lost it from diabetes and eventually gangrene. A doctor at Angel Hospital cut off half his big toe, then the rest of the toe, and later was about to cut off his foot above the ankle. Bennie figured the doctor was trying to squeeze money out of him, so he went to an Asheville doctor who cut off his whole leg near the hip.

According to Jimbud Rogers, Benny's leg is buried in the field adjoining his former home, now Ralph deVille's, but to date no ghosts have been sighted.

Maybe not sighted, but heard. Standing in the middle of town sits the mammoth Old Edwards Inn and Spa, a large complex including a hotel, spa, restaurants and shopping that was once just the Old Edwards Inn. As one of the only places to stay in town, it has enjoyed a long history.

One night, two different people, one of them a security guard, heard the sound of a person walking the second floor in the original part of the inn. No one was seen but the steps were very distinct, especially since they sounded like someone with a peg leg walking. The two people followed the sound from the Moose Room to the front desk, then to the dining room and finally to a window overlooking the fishpond. The sound then

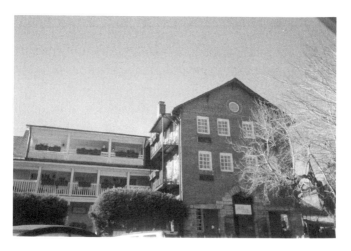

The Old Edwards Inn is completely remodeled, but stories of spirits haunting its halls are still associated with it. *Photo by the author.*

stopped, as if the peg-legged person was looking out the window, and the two didn't hear the sound again.

Was it old Bennie Rogers, stopping in for a check on Old Edwards Inn? The security guard and the other person were too frightened to investigate further. And if it was Rogers, history tells us they had a reason to be worried.

4½ STREET INN
Scent of Lilac Wafting in the Air

There really is a road named 4½ Street, halfway between, as you might imagine, Fourth and Fifth Streets. It is only steps from downtown Highlands and is lined by mature trees with genteel houses nestled among them, the road sloping up into a perfect sledding hill for when snow covers the landscape. It is here that the 4½ Street Inn sits, a welcoming house with a wide wraparound porch and a yard dotted with birdfeeders.

This house might seem so welcoming because of its long history as a guesthouse. Originally built by Irvin Rice around 1910, it functioned for many years as the Fairview Inn, a popular boardinghouse as well as a neighborhood favorite for a good meal. It is easy to imagine laughter around the dinner table floating through an open window on a warm summer day, the scent of biscuits and coffee wafting through that same window on cool mornings.

The 4½ Street Inn has a warm, welcoming atmosphere and a ghost who sometimes likes to be noticed. *Photo by David Bass, courtesy of the 4½ Street Inn.*

These days, laughter emanates from the home during the wine social hours each evening for guests at the 4½ Street Inn. The good-natured smiles of innkeepers Rick and Helene Siegel add to the warmth of the place, and Helene is known for her scrumptious homemade cookies that she often bakes in the inn's kitchen. So it only makes sense that a place which invites people to spend time again and again might have a presence that does not want to leave.

Shaffner writes that

> *in the not-too-distant past Ellie Pierson Potts' ghost* [allegedly] *still moved furniture and broadcast the*

scent of her lilac perfume. She claimed the rear room over the kitchen.

Emma Potts Pell discounted this report of her mother's ghost as dreamed up by a member of the Community Players when they summered in the house. This member noticed empty chairs rocking at odd times on the wraparound porch and heard unmistakable movement upstairs, phenomena Emma attributed to wind and bats.

But many people other than Potts's daughter attribute the sounds and strange occurrences to much more than artistic imagination, no matter the source of the events. Since the Siegels have taken possession of the structure, they have documented various "unexplainable" things that seem to happen at the 4½ Street Inn. In the afternoon, while guests are away from their rooms, the Siegels have heard the sound of a television blaring loudly on the second or third floor. There have also been guests who have mentioned to the owners about things having been moved without explanation, or at least not found in the place they last remembered having left them.

"When we were first working on renovations of the house, some of the building materials would be moved," Rick says.

On one particularly active night, three separate groups of guests in three different rooms experienced

the shaking of their beds three times. It seems as if someone desperately did not want to be forgotten.

Although the activity seems to be centered in the guest rooms on the second and third floors of the inn, the downstairs area, where the famous wine social hours occur, is not without its share of strange occurrences. There are definite cold breezes that waft through the hallway and downstairs rooms, and the Siegels have checked many times for the quintessential drafts in order to explain these distinct changes in temperature. Also, both innkeepers report seeing shadows out of the corners of their eyes, as if someone was moving about just outside their fields of vision. There was one instance where a dog reacted as if seeing a stranger, and when they went out to the hallway to investigate, felt a distinctly chilled air pass them by.

The innkeepers insist that their resident spirit is friendly, just there to check on things and occasionally make her presence known. But the scent of lilac still lingers in the air, sometimes over the scent of Helene's chocolate chip cookies, so there is no doubt that the history of the house will remain in the minds of those who enjoy the house today.

WERDER HOME
Oscar Likes Things Neat and Tidy

Up on a hill on Hickory Street lies the home of Bruce and Barbara Werder. A truly graceful country residence with a wide porch and well-tended landscaping, it was originally built in 1890 by Henry Downing of Yazoo, Michigan. The Werders operated it for years as a bed-and-breakfast, but they have recently gone before the board of Highlands to redevelop the property, although still promising to preserve the main house.

The home has had many owners throughout the years, but for the purposes of this story, most notable was A.B. Michael, a citrus pioneer in Florida, whose family inhabited the home during the '50s and '60s. According to the Florida Office of Cultural, Historical and Information Programs, Alfred Benjamin "A.B." Michael, considered the "Dean of the Florida Citrus Industry,"

The Werder home is "home" to at least two entities. *Photo 2005 by Randolph Shaffner, courtesy of the Highlands Historical Society.*

was born August 28, 1877 in Paw Paw, West Virginia. He moved to Florida with his parents in 1886. At the age of 13, he became ship's cook on a two-masted schooner and by the age of 17 was captain, a position he held until 1900. In 1902 he started a citrus grove on Orchid Isle near Wabasso. In 1917, he consolidated his holdings with the Deerfield Grove Co. of Cocoa and assumed full control of the company two years later. His Orchid Island grapefruit were shipped throughout the world. Michael was a founding director of the American Fruit Growers and the Florida Citrus Mutual, and was a charter member of the Indian River Citrus League. He also served on the Everglades National Park Commission and on the Florida State Chamber of Commerce Board of Directors. Alfred Benjamin Michael died February 26, 1964. His Great Floridian plaque is located at the Town of Orchid Town Hall, 9970 North A1A, Orchid.

He and his wife had the same birthday, August 28, and they used to throw an annual birthday bash at their home in Highlands every year, inviting a lot of the small town. It is easy to imagine light and people filling the house during those annual birthday parties, a late summer tradition as the days began to cool toward the coming fall.

When the Michaels resided in Highlands, they had a man, Oscar, who worked for them. Oscar took care of them and their two children, a boy and a girl. Oscar would bake delicious gingersnaps for the children and if anyone went looking for him, they would most often find him outside, tending his prized dahlia garden.

Now here is where the story descends into a spinning tale, for the next parts of the story cannot be substantiated, but still are repeated far from the Florida Highway on which they are set. So here it goes…Life was good for the Michael family, until one return trip from Florida to Highlands.

The family was traveling in separate vehicles, Michael alone, and his wife and children in another car together. By amazing coincidence, the entire family was tragically killed in separate car accidents, leaving Oscar without employment on top of the tragic loss of his longtime employers.

Oscar, of course, had to move out of the house, and it was sold. He spent the rest of his days down the hill in Brevard and died more than five years ago. Since then, Barbara Werder—the new owner of the house—says that his spirit has been evident in their home.

"Things will be missing or in different places in the shed. Things will be on the floor, or things left in the park will be back in the shed," she says. So at the Werder home, Oscar seemingly does not like gardening

tools left outside. If you happen to forget, he'll put them back in the shed for you. But Oscar is not the only presence Werder reports connected to the home.

When the house was repainted some time after the family's death, a painter saw a friendly girl in white coming down the staircase. It was late afternoon or early evening, and the apparition looked to be a girl around ten years old, no older than thirteen or fourteen. Neither the painter nor anyone else ever saw her again, but the loft room upstairs, which is presumed to have been a girl's room, is connected to even more strange events.

"When we first bought the home, we had a new toilet installed in that room," Werder says. "That toilet would run with no one there to flush it. There have also been lots of creaks and noises, including footsteps when no one was upstairs. Oh, and when we first moved in, the fire alarm would go off in the house for no reason."

The Werders ran the home as a bed-and-breakfast for close to ten years, and often, Werder would move about the home in the late afternoons, tidying up rooms and getting things ready for the social hours.

"Sometimes the upstairs hallways would be like walking through a fog bank, and it was a different temperature up there," she explains about that time. Werder often smelled a heavy scent of perfume and says "that loft room has no heat or air conditioning,

but darn if that room does not always stay a constant temperature."

Despite Werder's late-afternoon experiences upstairs, she says guests never reported anything bad in that room. "In fact, it was like always the opposite. They loved the room, they were having a great time, and everything was perfect."

On the other hand, one couple staying in a downstairs room at the inn had a somewhat frightening experience. Werder recalls that the couple only stayed one night, but they were very interested in history, old houses and the paranormal. They asked a lot of questions about the house, and Werder told them what she could.

About 4:00 a.m., the bowl-shaped ceiling light fixture in their room shattered, showering glass all over the couple and their bed.

"I got up because I had heard glass shatter and brought a broom. They were not hurt, and they seemed very calm, not angry or anything. I swept up the glass, and they went back to bed. There was something very weird about the whole thing," she says.

Werder habitually cleaned the fixture, and reported that there was no stress fracture on the glass. In addition to that, the bolt holding the fixture to the ceiling remained intact after the shattering, proving that somehow the glass had just exploded away from the bolt. Although she did not say specifically, could

it be that the couple had been trying to "summon" something?

But as many other people who experience the paranormal, Werder insists that the ghosts in her house, particularly that of the little girl, "are unbelievably happy presences. Hard work seems to go easily in this house, and everyone who has stayed in the loft room has had a good experience. And the house is just friendly."

THE LOG CABIN RESTAURANT
Dark Shadow Figure

Some people have had a lasting impact on Highlands, and Joe Webb was one of those people. His architectural stamp can be seen all over town through the homes he built for early Highlands residents. The 1920s were a golden age for Highlands as a vacation refuge, and during that decade, Joe Webb began constructing his distinctive style of log cabins around the area.

Ran Shaffner explains the unique style of a Webb cabin and why it fits so well into the Highlands landscape:

> *Joe Webb's rustic style, unlike the Adirondack style of upstate New York which it resembled, lacked the whimsical details and polychromatic color schemes of European architecture. His cabins, like the architecture favored by the National Park Service in western North Carolina and eastern Tennessee, were more natural. Vertical logs cover the foundation and fill the gable*

ends. A large central room with exposed logs spanning the ceiling. A staircase with slender log balustrades and half-log steps. Built-in furniture and rustic style bed frames. Round poles with saddle-notched corners.

Joe Webb cabins are revered in Highlands. They have been well-preserved and are very desirable on the real estate market. But what if you do not have the clout to purchase one of your own? Then you can visit The Log Cabin Restaurant in Highlands, an authentic 1924 Joe Webb cabin and home of some of the best cuisine Highlands has to offer—and maybe an added ghostly presence lurking around its white tablecloths and outstanding artwork.

Matt Thole is the new chef at The Log Cabin. He is excited about his new menu, which will include grilled antelope with vanilla ginger sweet potatoes. But one item he will not remove from the classic Log Cabin menu is its steak; the restaurant is known for them. Thole recently relocated from Asheville, and only one or two days after he started working there, late one evening he was settling into his new kitchen and prepping for the next day when he had a strange encounter.

"I kept seeing something out of the corner of my eye," he recalls. "I saw a figure, and I couldn't tell if it was male or female, but I saw it standing there.

"Well, I've worked in enough restaurants in old buildings to know about ghosts, so I started talking to it. As soon as I did, I felt a full-body chill run through me. That night it made its presence known and turned on a light as well."

So after only two days on the job, it seems that this presence wanted to check out the new executive chef. He's seen things out of the corner of his eye since, but nothing like that first night. And he does not believe the presence is harmful or even mischievous—just watchful. Thole sometimes feels as if someone is watching him when there is no one there.

Some of the other employees of the restaurant have had no experiences of ghostly activity, and one woman says that she stays late at night and is never worried. "I don't believe in them," she says. However, the original owners of The Log Cabin Restaurant supposedly told people that they saw the form of a woman walk through the dining room on several occasions, especially when they were doing renovations to turn the residence into a commercial building.

Although no one can confirm it, the story repeated through town is that a family used to use the cabin as a summer home with their primary residence in Atlanta. In the Atlanta house, one female member of that family committed suicide, either a wife or a daughter, and this tortured soul is the one that is stuck in The

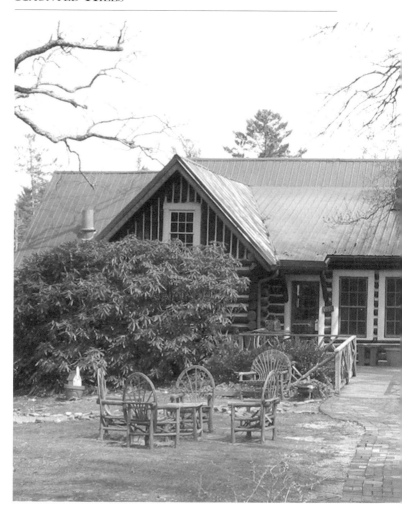

The Log Cabin Restaurant has a presence that likes to check out what's going on in the kitchen. *Photo 2007 by Randolph Shaffner, courtesy of the Highlands Historical Society.*

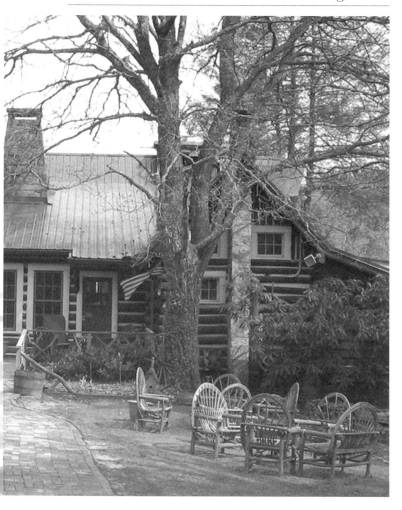

Log Cabin. These are just rumors or conjecture. But there is a dark figure, and the executive chef knows she (?) is there.

Satulah Mountain
The Legend of a Magical Mountain Volcano

Satulah Mountain is Highlands's "own" mountain. It sits as the dominant feature on the town's horizon, and many visitors each year walk to its crest. It has been the subject of controversy, too; the top of Satulah is part of the Highlands-Cashiers Land Trust, but other parts winding to the top are privately owned, creating accessibility issues that chafe many residents who see the mountain as public property, regardless of ownership.

However, Satulah was once all wilderness and trails, and early in Highlands's history, people felt the urge to explore it, climbing through native hemlocks and green ferns to see its beautiful view. The landscape, even today, seems untouched and wild. The dwarfed white oak and white pine on the summit can be two hundred years old and yet no bigger than ten inches in diameter. But the mountain has more than gorgeous

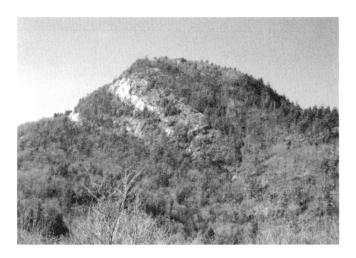

Satulah Mountain. *Photo 2001 by Randolph Shaffner, courtesy of the Highlands Historical Society.*

scenery—to some it has a secret that lies deep beneath its surface. People have reported smoke, rumbling, and one unsubstantiated rumor even said that it erupted in 1884, a volcano in the Blue Ridge.

Lynn S. Fichter and Steve J. Baedke, faculty in the department of Geology and Environmental Studies at James Madison University, explain how a volcano in the Blue Ridge is simply not possible:

> *For many people a mountain is just some place that has an elevation significantly higher than the surrounding area. The Appalachian "Mountains," for example,*

or the Blue Ridge "mountain." You know they are mountains if you have ever tried to climb them; it takes a lot of time and effort, and the view at the end is worth it.

But when we speak of mountains here we speak of them geologically, and that is often not the same thing as the everyday term "mountain." The modern Appalachian Mountains, for example, are not "mountains" in a plate tectonic sense. That is, they have not been created by dynamic forces currently thrusting the land upward. The Appalachian Mountains are in fact more complex than that. The rocks that make up the mountains are the fragmented, eroded remains of at least four ancient mountains that were huge compared to the present ones (anywhere from 5 to 10 times taller). And the structures in the rocks that give the Appalachian Mountains their distinctive valley and ridge shapes and sizes are ancient structures created in a former mountain 300 million years old, and long since dead and gone.

Instead the modern Appalachian Mountains are the result of a gentle, almost passive uplift, followed by erosion that has removed the soft rock in the valleys, and left the hard, resistant rocks at the ridges. It is the last few subdued breaths before the whole region goes to sleep.

Simply put, volcanoes are part of an active mountain range, not one going to sleep. However, that does not stop some people from insisting that Satulah has a voice, and a rumbling one at that. Shaffner writes:

> *The most definite assertion of Satulah's volcanic nature came from Soyrieta Law quoting Dolph Picklesimer, who was hog hunting on December 10, 1884, a year and a half before the Charleston* [SC] *earthquake, and "was nearly scared to death on the crest of Satulah by sulphur fumes and rumblings from within the mountain as loud as a freight train. He felt the intense heat through his heavy cleated logging boots and fled down the mountain in terror as hot rocks and sulphur fumes spewed into the air." Mrs. Law claims the Cherokees reported disturbances as early at 1730 and wouldn't go near Satulah, which they called Big Grumbler Mountain.*
>
> *Who is to doubt that Satulah has grumbled at times in the past, even within the last hundred years or so? But an eruption of hot rocks and sulphur fumes, such as Dolph described, would surely have made its way into the* Blue Ridge Enterprise, *Highlands' local newspaper, which appeared the next day and each week thereafter, but regrettably no notice was taken.*
>
> *Helen Hill Norris relates a milder account of Dolph's experience. He told her grandfather, Stanhope*

Hill that—short of an eruption—the mountain was definitely rumbling. Up near the cliff called the toadstool, the rocks were hot enough to heat his shoe soles. Stanhope Hill accompanied Dolph home, but could confirm only "a faint, far off roaring which seemed to be coming from a few cracks in the mountain, but seemed to hold no menace."

For those who do not believe the tales of rumbling hot activity, perhaps some sort of light or energy phenomenon might be more to your liking (in the same vein, possibly, as the famous Brown Mountain Lights in another region of the North Carolina mountains). Shaffner has documented that kind of activity as well:

Irene James, Dolph Picklesimer's niece says she doesn't remember these stories in her family, but she does remember an incident when she was in her teens and she and her sister Mett and Irene Kinsland were walking the trail to brother Lyman's house in the gap between Satulah and Fodderstack, and a light followed them all the way up through the woods. "That was the nearest I ever came to seeing a ghost," she says. "I figured there must be some mineral going along with our bodies."

Although it is difficult to say exactly what James meant by "mineral," possibly she meant that some

kind of natural force was there with them as they crossed the mountain. She no doubt thought that their presence had attracted something, and she attributed a personality to it since it "followed." Lights and entities in the forest and wild places are a long-standing tradition, especially for the people of the British Isles, the same people who settled much of the Appalachian region. Faeries and sprites were commonly depicted as light, and they were seen as part of the natural world.

Highlands Inn
The Lady in Room 34

Highlands Inn is a jewel of Highlands's picturesque downtown. Its open face with wide porches and rocking chairs welcomes visitors to the area and those just walking by. It is lovely, especially when the casual visitor realizes that they might be able to spend a night resting under its eaves with cool mountain breezes wafting through open windows and the quiet sounds of Main Street just steps away. The inn has been a witness to Highlands's goings-on since nearly its very beginning, and yet its lobby and Kelsey Place Restaurant (serving lots of home-style goodies) are just as inviting as they were the day it was built. Simply put, it is one of those buildings that invite you to stop and stay for a while—the same function it has performed for more than one hundred years.

One of the earliest photographs of the inn shows bewildered guests gazing over the dusty, earthen Main

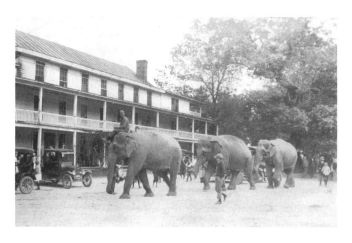

Guests at the Highlands Inn were surprised to see a parade of circus elephants on the plateau. *Photo 1923, courtesy of the Highlands Historical Society.*

Street as a group of elephants calmly walk by. It was all part of a visiting circus that somehow made it up the mountain trail.

When Joseph Halleck built Highlands Inn in 1880, it was the first hotel in Highlands, known as Highlands House. In 1883 Joseph Fitts bought the inn and was running it when the Moccasin War took place in 1885. In 1886 John Jay and Mary Chapin Smith were the recipients of the inn, a wedding present from Mary Chapin's aunt, Eliza Wheaton. This was the same couple that lived in the Gray Cottage just a few steps away from the inn. During this era the inn was known

as the Highlands House and fondly referred to as Smith House.

The inn became known as Highlands Inn around 1925, after Frank Cook purchased it. Miss Helen Majors, a Canadian by birth, bought the inn in 1969. She lived in the inn (in the room now named "Miss Majors") and ran it full time. Majors had a passion for popcorn, and to this day you can occasionally smell the unmistakable aroma of popcorn.

Sometime in the 1970s, the inn was refurbished and enlarged on the back, creating fourteen more rooms. In 1989 there was an extensive renovation and gutting of most of the building, and in 1991, the Highlands Inn was listed on the National Registry of Historic Places.

Highlands Inn celebrated its 125th anniversary a few years ago, and there might have been an extra guest at the anniversary celebration. Most guests might not have noticed her—a mere flicker in the mirror or a shadow in the hallway. But for some of the inn's patrons who have stayed in room 34, she has provided a real and confusing paranormal experience.

"I don't doubt she's here, and if she's here, she's a part of the inn and friendly," says Tim Rhodes, Highlands Inn general manager.

Rhodes has never had any personal experiences but does admit that more than a few guests have.

"These are reputable guests or people who don't even know the legend of the room," Rhodes explains. "We usually don't mention the history of the room when people check in, and there are still stories. However, we don't hide it, and some guests even request that room."

For some reason, the activity seems to center on the bed and nightstand. One guest awoke to a sound in the night but could find no cause. The next morning, she noticed that her keys, the keys she left on the nightstand, were on the floor about three feet away from the table. Upon recreating the scene, she realized the sound she had heard in the night was the sound of keys being thrown on the floor.

Other guests have experienced a more puzzling sort of manifestation. A woman staying in room 25 reported that her blood pressure pill was missing from the nightstand. She said she looked all over the room and finally found it underneath the nightstand—where it could not have dropped on its own because of a table skirt that pooled at the floor around the stand. But there it was, her medicine sitting squarely in the middle of the patch of carpet underneath the table, as if it had been hidden by a mischievous person.

"That was unexplainable, but room 25 is directly below room 34. If she can glide through doors, why not the floor?" asks Rhodes.

Another time when a housekeeper cleaned room 34, she found a pain reliever under the middle of the bed. No one had been staying in the room, so the pill just "appeared."

Does the "lady" collect pills? Did she die of an accidental overdose and worries that someone else will?

Highlands Inn cannot answer those questions, but they do assert that the presence in and around room 34 is female.

When Tammy Steele and her husband came to Highlands the week of October 12, 2002, they checked into room 34 on the third floor overlooking Main Street. The room is cozy and inviting and offered the perfect setting for their weekend getaway.

Sometime between 6:00 and 6:30 p.m. on Saturday evening, while the waning autumn sun still lit the room, Tammy returned to room number 34 after her day on the town. She sat on the corner of the bed in front of the middle window overlooking Main Street to remove her boots. Suddenly she felt a cold chill, like an air conditioner was blowing on her. Thinking her husband had returned, she looked up from her task. But instead of her husband she saw a lady approaching from the window in front of her.

"She was almost solid, but I could see through her as she walked from the window past the corner

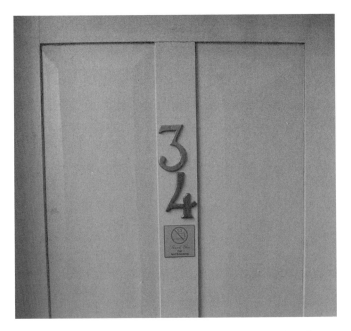

The ghost of room 34 is known for hiding things. *Photo by the author, courtesy of the* Highlander.

of the bed toward the door behind me," says Steele. "She never looked at me, just the door, and the closer she got to the door, the more transparent she became. By the time she got to the door I could barely see her and then she just disappeared. I don't know if she walked through the closed door or just vanished. The door never opened and she just wasn't there anymore."

The disappearing visitor had on a high-collared blouse and a dark skirt that trailed behind her.

"She was thin, but not real skinny, about five feet tall," she says. "I saw only her profile, but she looked pretty. Her hair was dark and piled on top of her head in a bun."

And the lady in room 34 can be "seen" in every photograph taken of the room.

"All the mattresses in the room were replaced at the same time, but no other bed looks like that one in room 34," Rhodes says.

No matter what the staff does, it always looks like someone has been sleeping on the right side of the bed. They will make the bed only to return a little while later and find an indentation on that side of the bed.

Rhodes says, "It looks like someone has taken a nap there or is sitting there."

But although Rhodes has trouble keeping the bed smooth in room 34 and occasionally sees an unexplained reflection in one of the many mirrors in the inn, he says he does not want to be anywhere else.

It is certainly possible that the inn could have more than its share of otherworldly guests who feel comfortable staying the night. Highlands Inn has been in continual use since its beginning, and its wide front porch has served many visitors who "grew up in the inn" and have returned with their families year after year.

"I love it here and it has always been my dream to run a country inn. This is a wonderful place," Rhodes says.

Seems like the lady in room 34 thinks so too.

Cashiers

The town of Cashiers sits between Lake Toxaway and Highlands at the intersection of Highways 64 and 107. Originally known as Cashiers Valley, its landscape is lush with mountains framing the view. Like its cousin Highlands, it is dotted with high-end custom homes, golf courses and private country clubs. But unlike Highlands, Cashiers has more of a hardscrabble history in some respects.

Cashiers was originally settled by farming pioneers, but soon more industrial pursuits such as mining and logging grew up around the area. When South Carolina Governor Wade Hampton discovered the area and built the Hampton House, bringing dignitaries and influential people to the valley, there was immediately a juxtaposition of the working class with the genteel class. It has remained much the same to this day.

Whereas Highlands has a Main Street, Cashiers has a crossroads, and it is there that the businesses cluster. It is not really a pedestrian friendly stretch of road, but classic antique shops, restaurants and art galleries are tucked in among the trees along Highways 64 and 107.

In addition to the shopping, there is a good bit of ecotourism here too, and hikers, anglers and kayakers use Cashiers as a "base camp" for natural pursuits all over the region. The Horsepasture River is known for its trout, the Appalachian Trail is not too far away, and there is a multitude of waterfalls to explore.

Cash's Valley
The Legend of How Cashiers Got its Name

It is very easy to tell who is familiar with the town of Cashiers and who is not. Although the spelling suggests otherwise, the town name is actually pronounced "Cash-ers," not "Cash-iers." It is an immediate telltale sign to others that you are from "off" if you do not pronounce it the correct way.

But how did this beautiful valley town get its name? Was it from some kind of bank or cashier's office located here in the past? Seems logical, but no. Supposedly, it all boils down to a horse.

First, there is no definitive answer on the naming of Cashiers, so differing legends have been espoused at one time or another. Because of the Cherokee history of the area, one legend recorded in the *Asheville Citizen-Times* has to do with a Cherokee who declared "Cass hears!" after a deaf girl was struck by lightning. Another legend has it that the valley was originally named "Cassius

The view from Falcon Ridge is one reason Cashiers is such a popular tourist destination. *Photo courtesy of the Cashiers Area Chamber of Commerce.*

Valley" after Wade Hampton's bull that got snared in a thicket in the valley and broke his neck. But most folklorists and historians agree that a slurring of a horse's name is how the valley got its name.

The Cashiers Area: Yesterday, Today and Forever states the following:

> *One believable source concerns James McKinney, wife Sarah and 17-year-old son Allison, the second settlers*

in what became Cashiers Valley. The McKinneys came from the Pickens District in South Carolina in 1835, not many years after the Cherokee Indian Tribes had ceded their land in western North Carolina to the United States. Before McKinney bought 600 acres (some of it now a portion of the High Hampton resort), he had kept his cattle and horses in the lush valley during the summers and herded them back to South Carolina for the winter.

Among his horses was a white stallion which had cost him so much that he called it "Cash." One autumn McKinney failed to find his horse for the round-up. When he returned the following spring, much to his surprise, he found Cash alive and thriving in the valley. He began to call it "Cash's Valley," and over time that name was slurred into "Cashier's Valley."

This quite believable explanation was somewhat supported by the first settler, Colonel John A. Zachary, who came from Surry County in North Carolina with one of his sons in March, 1833, after he had explored the valley in the fall of the previous year. That year of 1833, the Zacharys built two cabins, put up the walls for a two-story log house, cleared 20 acres and raised a crop before returning for the winter to Surry County.

Long remembered in the Zachary family is the story that the valley was named for a horse called "Cash" owned by a settler who lived about five miles south

of what is now Glenville. This "Cash" came by his name because he had won his owner a goodly sum of money in racing. One day the horse wandered off south a ways, came upon good feeding in the valley and would not leave. Thus another "Cash's Valley," and some parallels to the McKinney version …

One indisputable fact is this: the first post office in the valley was called "The Cashiers Valley Post Office," established on November 7, 1839, with Jonathan Zachary as postmaster. That date was only a few years after the Zacharys and McKinneys had arrived and long before poor Cassius took his tumble.

THE ETERNAL BLOODY ROCK
Massacre at Cold Springs

Feuds between families seem old-fashioned, senseless and even silly. The famous Hatfield-McCoy feud has been parodied and stereotyped in aspects of popular culture from fiction to cartoons, so much so that it seems to have lost its bite, its sinister quality.

That is not the case for a Jackson County family feud, for it is almost lost to history, although in some spots it is as if the blood is as fresh as it was more than a hundred years ago, and that blood shines fresh for anyone who looks to see.

There are differing versions as to how the feud between the Hoopers and the Watsons started. Some say it was a dispute over a silver mine or lead mine; others say that it was a dispute over grazing rights. Many of the accounts were simply passed on through oral history, so, suffice it to say, the feud started as so many did—over the land and a family's rightful

claim to it. The strains of the War Between the States seemed to add fuel to the fire, as the Hoopers and the Watsons did not see eye to eye—not surprisingly.

For much of the Appalachian south, the Civil War was a war of division; it wasn't as simple as defending the homestead or fighting for state's rights or the right to own slaves. The Civil War divided the Appalachian frontier. It was common to see Union sympathizers buying feed in the same general store that served Confederate volunteers. For people who rarely owned slaves and for whom the fights of Charleston Harbor seemed like bedtime tales, war sympathies divided a culture set on individual rights and solitude.

And for the Hoopers and the Watsons, divisive war sympathies added fuel to an already smoldering fire. The Watsons and the Hoopers were on opposite "sides" as it were, and although there had been random killings here and there, it was the Massacre at Cold Springs that really sent the Hooper-Watson feud into grisly legend.

The Hoopers had been binge drinking for more than a week, consumed by family solidarity and whiskey. After sitting around a few days, fueled on alcohol and thoughts of murder, they were not content to let those thoughts remain dreams—they plotted to make them bloody reality.

Little waterfalls such as this one (frozen during the winter) are characteristic of the Cold Springs area. *Photo by the author.*

Walter Middleton, a descendant of Jackson County, recounts the tale that was passed down to him by his family in his book, *Trouble at the Forks*:

> *However, one great grandson tells it this way. He said that the gang didn't all get to their destination at the same time. He said that Monroe Hooper stopped off along the way somewhere at his aunt's house (Jemima H. Wilson) and told her what was about to happen, confessing that he was too nervous to load his gun. "Give it to me," she said, "I'll load it. Hand it here, I'm not too nervous." Her son was later quoted as*

saying he knew his mother was suffering in hell for her meanness, for she was no saint.

Neither was Monroe anything resembling a saint, despite his misgivings about loading his weapon. He was just suffering from the drunken shakes. When Monroe arrived at Cold Springs, the others of the gang had already crashed the door of Robert Watson's house and had gone in shooting and abusing the family. At one point, two men who were said to be Burl Watson and his brother were bound together with a rope.

Monroe, who had just arrived, was having his kind of fun. He shot and killed one of the two prisoners who were tied together. The other prisoner attempted to escape, dragging his dead brother along. But Monroe wasn't about to let that happen. He shattered his rifle stock over the man's head and left some of it sticking in his temple.

What happened in the house was equally as barbaric, according to a wife who escaped with her eight-year-old son out a back window. Two or three other Watson men were murdered a little at a time like a cat and mouse game. The son whom the mother took through the window and out into the night was Leander who later told that his mother was raped and his grandmother killed before he and his mother escaped…

So much of the horrid story has ended in cemeteries in Pine Creek and Yellow Mountain districts. There

are as many as four headstones in Watson family plots bearing the same death dates. Some graves have women's names and dates, while others unknown lay beside them with no information on the headstone. Possibly, some graveyards do talk.

Eliza Hooper, who was born and raised on Upper Pine Creek 93 years ago, shared a legend with us. According to her, there is a large flat stone near the present community building that tells a story of a man's blood that a murderer shed on that particular spot. According to another old-timer who heard it handed down, there were two men having an argument standing on what they now call "Bloody Rock." One, a Watson, accused a Hooper of killing his hog. Hooper denied it, and started to fight. So Watson cut the man's throat.

To this very day, the bloodstains are right there on the rock in spite of all the rains and snows that have come since that time. At various times, residents have tried to remove the bloodstains, but to no avail.

Eliza told me that Lilly Bill scrubbed the stone with lye soap, which only made the stain brighter. People say that a murdered person's bloodstains just might stay where it was shed forever.

These horrible incidents left fear and hate among residents and relatives who swore vengeance on the perpetrators. It created uneasy living in such a small neighborhood, especially when men were liquored

up. Remember that these were primitive people and were usually related in some cousin sort of way. The murderous way of some brought a shame to others who were akin.

Eliza says that if a person wants to see "Bloody Rock," just make a trip up on Upper Pine Creek and see for yourself. "It's still there yet, gist as bloody as it ever wuz."

So the Hooper and Watson feud did not play itself out through a single incident; the feud lasted through fights and murders and insinuations and births and deaths. For Cashiers and the surrounding area, the fight between the families took on mythic proportions, and whether it was real or imagined, the feud gained gruesome "documented details."

Gary Carden, Appalachian storyteller and a columnist for *The Sylva Herald*, remembered his grandfather's tales of heads on stakes in reference to the Hooper-Watson feud. He writes in that same column that he found evidence of the gruesome poles:

Forty years later, I blundered on an unusual book, Status Quo, *written by S. Van Epp Law. Essentially, the book is autobiographical and covers the author's life in both Florida and Cashiers Valley. However, as I surfed through the 205 pages, I suddenly found myself*

gawking at a strange sketch of what appeared to be an assortment of human heads—some on stakes and others hanging from tree limbs. Beneath this grisly illustration was a graphic description of what the author called "the Hooper-Watson feud." Apparently, I had stumbled on the original tale that my grandfather had told me about.

Heads on stakes. That's a far cry from idyllic streams and the solitude of the trails of Whiteside Mountain.

HIGH HAMPTON INN
The Ghost of the White Owl

A 1,400-acre resort that includes a private, 55-acre lake, the High Hampton Inn in Cashiers is a place of rustic elegance set against backdrops of lush hemlocks, amazing mountain views and a well-loved golf course. A playground for the "comfortably situated" for more than two hundred years, this once-quaint hunting lodge has blossomed into one of the anchors of Cashiers Valley.

High Hampton Inn is listed in Historic Hotels of America, a program of the National Trust for Historic Preservation. Besides its amazing location and well-preserved architecture, its significance to the list is also due to its history, as is detailed on www. historichotels.org:

> *In the mid-1800s, the Hampton family found refuge here from the oppressive summer heat and humidity of*

their native South Carolina. Wade Hampton III had a deep love of the area and constructed his personal retreat, the Hampton Hunting Lodge, just prior to the Civil War. After serving as a general in the Confederate army during the bloody conflict, Hampton returned to the lodge to rebuild his spirit. It was on the Lodge's front porch that he later received the news that he had been elected governor of South Carolina.

In 1890, the property passed to Hampton's niece Caroline and her husband, physician Dr. William Halsted, who renamed the property High Hampton after his family's ancestral estate in England. In 1922, High Hampton was purchased by E.L. McKee who constructed a two-story inn on the grounds. The McKee family still welcomes guests and the mountain breezes still refresh the spirit, just as they did in Wade Hampton's day.

Dr. William Halsted and his wife, Caroline, were fascinating figures. Although Caroline had been raised by three maiden aunts after her mother's death, she shocked everyone by packing her bags and moving to New York City to attend nursing school at the end of the nineteenth century. She then moved to Baltimore and to Johns Hopkins Hospital, where she met Dr. Halsted, and their relationship eventually went beyond doctor and nurse.

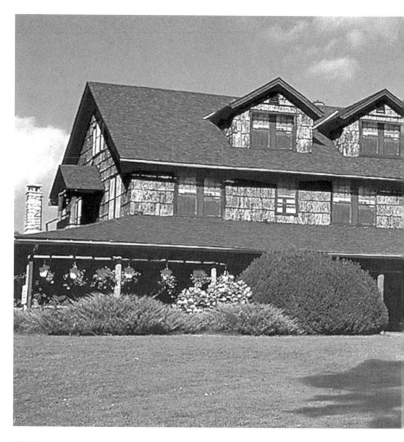

High Hampton Inn as it looks today. *Photo courtesy of the High Hampton Inn.*

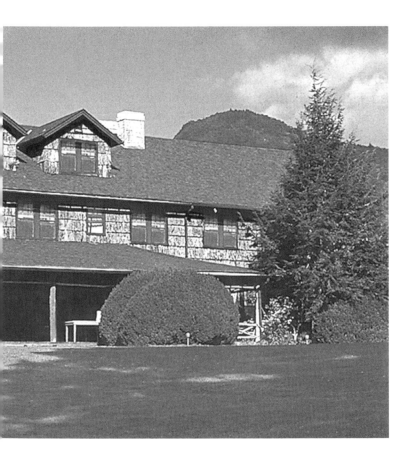

Dr. Halsted was a prominent figure in medicine at the time. A respected physician and researcher, he helped forge new techniques for surgery at an exciting time in medicine. Dr. Peter Olch, deputy chief of the History of Medicine Division, National Library of Medicine, reveals how one piece of now standard equipment was first introduced into the surgery room:

> *Rubber gloves were actually introduced into the operating room because of the sensitive skin of one Caroline Hampton. She was a scrub nurse, and of course, she was continually immersing her hands in mercuric chloride. After she developed a severe dermatitis, Dr. Halsted arranged to have the Goodyear Rubber Company make some thin rubber gloves strictly for her use.*

It was later that another doctor took the discovery and realized that they were wonderful for sanitation as well, and of course, it was later that nurse Caroline Hampton became Caroline Halsted.

The ghost of the white owl is really centered on Dr. Halsted's purchasing of the surrounding property. He wanted to increase the acreage of the estate, and started buying pieces of property ranging from 300 acres to 2,200 acres, up to his death in 1922. For one particular prospective seller, keeping the property was much more important than the money it would bring.

Louisa Emmeline Zachary married Hannibal Heaton in the late 1890s, and thus through marriage Heaton gained possession of Louisa's property, a prime piece of real estate now part of High Hampton Inn acreage.

Mark Jones, manager of High Hampton for twenty years, says that by all accounts, Louisa "wasn't all there," a Southern expression for a broad range of mental infirmities. There are even rumors that she tried to drown one of her children in Cashiers Lake. However, it came as no surprise when neighbors heard of her battle with her husband over her family's land.

One day, the battle became so heated that Louisa uttered these fateful words to her husband: "If you sell my family's land, I'm going to commit suicide."

However, Heaton was not to be swayed by the high-strung threats of his wife. Dr. Halsted was willing to pay premium for his piece of land, and as the man of the house, Heaton had decided to go through with the sale. So that fateful day when he came back with the money and the bill of sale, he found Louisa hanging by her neck in the barn, as a white-faced barn owl screeched and flew above her in the rafters. Heaton brought the neighbors, and many of them noted the owl as they helped lower Louisa's stiffening body to the barn floor.

At the funeral, where her body was laid to rest in the Upper Zachary Cemetery, Heaton was so distraught that he too tried to commit suicide by slashing both sides of his neck with a hunting knife. He was restrained and did not die from his wounds. Some say that his hair turned completely white in the three weeks after his wife's death. He decided that living in Cashiers Valley was too painful, so he moved to Franklin, where he lived for the remainder of his life and was buried.

Over the years, the tale has evolved with the telling, from a barn to an apple tree and from a barn owl to a completely white owl. Nevertheless, Jones reports that during his twenty years at the inn, many guests have told him of hearing the screeching of the white owl or actually seeing it somewhere on the grounds. There is even a painting in the inn by Lily Byrd McKee that further highlights the connection between owls and the inn itself.

WHITESIDE MOUNTAIN
The Legend of Spearfinger

Legend has it that Whiteside Mountain is the oldest mountain in the world, where the Land Below and the Beings Above met in conference with each other, the great granite façades bearing witness to the beginnings of the world. It dominates the landscape between Highlands and Cashiers, looming over Cashiers Lake with its reflection glancing back on a calm day.

It stands sentinel beside Highway 64 as the road starts the steep ascent to the Highlands plateau. No asphalt road touches it, just the footpaths that have been twisted about it since ancient times. It is a landmark, a destination and the defining element for the first windings of the Chattooga River.

Whiteside Mountain contains many wonders on or near its trails, but among its most famous is the Devil's Courthouse. Dr. Robert Zahner, a biologist

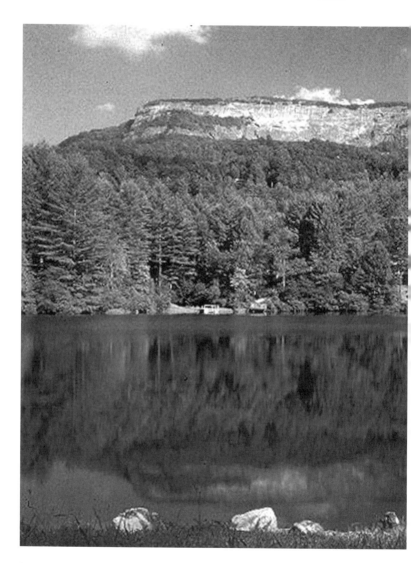

Whiteside Mountain is one of the dominate features of the area landscape. *Photo by Wayne Busch.*

with a lifelong relationship with Whiteside Mountain, describes the amazing rock formation:

> *When a first-time visitor arrives at this magical place, it takes little imagination to visualize a gathering of mythical beings on the broad, gently sloping surface facing west to a raised rock "pulpit," where sits a presiding spirit or lifeforce. The setting is truly inspirational, overlooking the upper basin of the Chattooga River, surrounded by majestic mountains, a place deserving a far more benevolent name. Close by to the south the mother mountain, Whiteside, looms watchful over all proceedings at the Courthouse.*
>
> *The central, open "council" area at the crest is surrounded by a natural rock garden of Catawba rhododendron, mountain laurel, and dwarfed specimens of Carolina hemlock trees. In late May and early June the shrubs are in full flower, decorating the Courthouse with purple and pink bouquets. On the northwest slope, off the crest, the Carolina hemlock become large trees, clinging to the edge of steep cliffs. These cliffs on the north side of the Courthouse are quite different from those on the smooth southeastern faces of Whiteside Mountain. The Courthouse cliffs, although completely vertical, have rough faces, with thousands of niches and cracks in which small plants grow. This plant community, consisting of many species of mosses,*

lichens, fungi, ferns, and a few rare herbaceous plants, is unique in the southern Appalachians. These north-facing cliff faces, unknown elsewhere, provide this rare habitat with just the right shade, moisture, and substrate for a rare combination of plants to grow.

In the early 1930s Herbert Ravenel Sass wrote a historical novel in which I understand the Devil's Courthouse played a prominent role. I have not been able to locate a copy of this book; therefore I cannot recite the story. I am told the narration was about the early Cherokees, with the setting at Whiteside Mountain. I can readily imagine any number of interesting plots that would utilize the appealing stage and backdrop of this setting.

As beautiful and fascinating as is the "council" area, the feature that attracts the most attention is the rock ledge at the easternmost point of the Courthouse. Here on three sides the ledge ends precipitously sheer vertical drop of hundreds of feet.

And it is here that Cherokee legend says the great Spearfinger lived, her home the rocky cliffs of Whiteside Mountain.

She was a loner, living among the cliffs with the rocks and peregrine falcons as her only companions. In fact, she was very much like the rock and the falcon. She was hard and tough, and on one of her hands she had

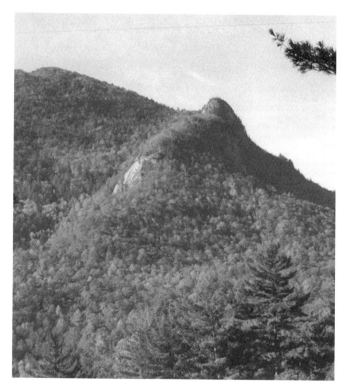

The area known as the Devil's Courthouse. *Photo courtesy of the Cashiers Area Chamber of Commerce.*

a stone spear in place of fingers, an amazing weapon. She was also a hunter, looking for young children on which to use that weapon.

The spear finger, able to remove organs without leaving a visible scratch, was also the source of the old

witch's power, for her hand was where her heart was located, beating inside her malformed palm. The odd location of her heart kept her protected in battle and showed where her true love was—within the power she held to kill.

Besides her formidable weapon, she was able to manipulate the rocks and build stone bridges between mountains. That way, she could escape easily. But when she was looking for food, she had to descend the mountain that she so loved and disguise her malicious intent.

Gary Carden, master Appalachian storyteller, explains how she wooed her victims:

> *Deception is her weapon. True, the stone finger is deadly, but she must get close enough to use it. So, when she descends the mountain, she moves with the slow, shuffling gait of a village grandmother. As she shambles downward, trying to tread lightly, she watches for the tell-tale wisp of smoke from the valley. Like fog and clouds, smoke makes her a dim form creeping towards her prey. Brush fires in the forest are especially helpful—the kind that the Cherokees start in the fall of the year, burning an entire mountainside so they can find fallen chestnuts, lying roasted on the blackened, smoking ground.*

The old witch moves through the smoke with her hand under her blanket, the deadly knife-finger concealed. As she watches the children gather hot chestnuts, her face assumes the guise of a village crone she has passed in the smoke. The discolored fangs withdraw; the fierce animal eyes dim.

"Ah, children, help a poor old granny. I need to sit and rest." The ponderous body feigns weakness; she draws the blanket closer, concealing the stone skin, the killing finger. She totters forward.

When the children look, they see only old Nadhi who is a familiar sight in the village. The thing that looks like Nadhi sits wearily and a little girl brings her a hot chestnut.

"Come, child, sit in Granny's lap and she will comb your hair." The child climbs into the old woman's lap, and the witch begins to croon and hum as she combs the little girl's hair. The child's eyes droop and she dozes. The other children wander away, filling a basket with smoking chestnuts.

So quick. Spearfinger can stop a heart without inflicting pain. With a deft twist, she can remove a liver and leave the flesh unblemished. Sometimes, she acts with such speed, the victim does not know that their life is draining away like water in a cracked jug. They return to their homes wondering why the world is growing dim. In a few days, they fade and die.

So Spearfinger became a feared entity. Whenever children inexplicably got sick and died, "Spearfinger got them." When children disappeared in the forest, away from the village, never to be seen again, "Spearfinger got them." Spearfinger was the reason. As the story goes, one day, Spearfinger speared a liver out of the son of a Cherokee chief. The chief was outraged and took one thousand braves up to scour Whiteside Mountain to look for Spearfinger. One version says that she escaped, another that the braves figured out the secret location of her heart and killed her with a stab to her hand. Nevertheless, Spearfinger's laughter is easy to imagine when the wind whips through the Devil's Courthouse on a cold, bleak, winter day on Whiteside Mountain.

SNAKES DEN
Jealousy for Bessie Laura

The mountains surrounding Cashiers are full of secrets—and some of the most beautiful waterfalls in the country. Transylvania County, the county directly east of Cashiers, is officially known as "Land of the Waterfalls."

Deep in the forest off Highway 281 north, there is a creek called "Dismal." This area's most striking features are its limestone shelves, its remote location and its amazingly beautiful waterfalls. Its breathtaking beauty is often worth the life-threatening trek to get there, but Jim Bob Tinsley, folk storyteller and author of *Land of Waterfalls, Transylvania Co., North Carolina*, calls Dismal Falls and the area leading up to it "one of the most foreboding places in the Southern Appalachian Mountains."

Long before county lines were drawn, the area became more than foreboding for two jealous suitors—

Dismal Falls's breathtaking beauty showcases the limestone ledges for which the area is known. *Photo by Rich Stevenson.*

it became a grave. The story made its way the short distance to Cashiers and was whispered around the fire and told in hushed tones when men gathered, and it is still remembered today.

The Dismal has many cliffs. Some hold beautiful rushes of water tumbling over their edges, others reach out into nothingness and rocks below. Walter Middleton details one such cliff in his book, *Trouble at the Forks:*

> *One cliff especially, spelled danger in a different way. They called it the Snake Den. It wasn't high or steep, just rather flat at the top and slowly rolled over reaching down eighteen or twenty feet. At the top, a layer of stone a yard thick jutted out leaving an opening under it.*
>
> *On warm days one could see a dozen rattlesnakes or more coming out of the opening and laying on the flat surface of the cliff in the sunshine. Sometimes two or more would coil up together or near each other on the warm surface. Both the black and yellow snakes had a section on their rattles for each time they had shed their skin. Some had only a few. Others had as many as seven.*

Far down the mountain from the venomous snakes basking in the sun, a young woman worked hard in the valley, her youth and strength aiding her everyday tasks. This was Bessie Laura, one of the prettiest girls around.

Middleton says, "Bessie Laura was country pretty. A natural smile with dimples and an honest to goodness sweet disposition made boys drool over the curves hard work had helped build under her dress.

"But nobody could accuse Bessie of being worldly. She just attracted boys like honey does bees, naturally."

It was only "natural" then, when two young men came courting Bessie Laura seriously, each competing against the other for her exclusive affection. But Bessie did not seem to encourage one more than the other, and while she was busy making up her mind, her friends and family chose the one who was more good-looking and had more money. Typical family.

But Bessie knew better, and she eventually chose the better man, the one with the good heart and the hard work ethic. Of course, after that, things escalated. There were threats. There were jealous whisperings, taunts. Then the chosen beau disappeared, and all feared the worst. There wasn't any law enforcement around the Dismal area—it was the American frontier really, just a few families bound together by a sense of place. But all went looking for the missing man. Middleton continues the story:

> *Someone thought to look in the caves down under Dodging Ridge.*

They found the young man there in a cave, dead from knife wounds. Of course, everyone suspected the jilted lover but not one item of evidence was found. The suspect was quiet and smug, answering, "I know absolutely nothing about that." A month or so went by and the peak of anguish was dying down some. There had been no closure for those who grieved. A spell of quietness slowly gripped the neighborhood. Some were thinking it was a little too quiet. An intuition expert or two began whispering little taddicks of news that hadn't happened. Numbers were ready to say, "I could have told you."

And it happened. Tom [the suspect] *turned up missing.*

In the small communities, men gathered into search parties after their farm work was done, looking into the deep dusk as it lengthened in the mountain shadows. They would come home to suppers that had been covered in a towel and left on the stove to keep warm. The men came home to cold biscuits and lamplight and still did not find Tom. After a while only the most diligent of men kept looking. Then after a while longer, all stopped looking.

It was only after a stranger came to the town and said he saw a man's body lying in the rattlesnake den— the snakes hiding in the darkness at the back—that

Tom was found. He was tied and dead, there among the snakes. His family always thought it was family revenge for the supposed killing of the other beau, and they kept the rope that had tied him as evidence. In fact, truth be told, the rest of the community thought mostly along those lines as well, until one middle-aged veteran was on his deathbed and decided to reveal all, as Middleton recounts:

> *Neighbors stood around and listened as the veteran told how he and other soldiers had been deserted at a very critical time in battle by a young Captain named Tom. They found him after they came home and were responsible for his demise.*
>
> *Grandpa said, as far as he could tell, the man showed no regret whatever for the crime.*
>
> *That wasn't the whole story. A majority of the returning veterans had a mind to work. They had seen enough of war and now as they witnessed results of the home side of war, they settled down to make their mountains all they might become.*

So Tom's family was living beside the men who killed their son, and those men were prospering. It was soon that their thoughts turned to love, and only naturally, one of them made Bessie Laura a very happy girl. Why should her dimpled cheeks always have tears on them?

CEDAR CREEK RACQUET CLUB
Pretty Little Brenda Sue

The flow of water is a constant around Cashiers. Streams trickle through green valleys, the Horsepasture River winds past Highway 64, and water tumbles over precipices and rocks to create many of the waterfalls for which the region is known. But water is also power, and in the 1920s and '30s, it meant power—electrical power—if you could dam the flow to harness it.

According to Blue Ridge Electric, "Life in the days before the late 1930s was dark and filled with manual labor from dawn to dusk for rural folks. While electricity had come to many towns and cities, it remained elusive in more distant areas because existing utilities found it unprofitable to bring it to rural areas."

Cashiers Valley was definitely a distant area, so even though other places in North Carolina (such as Wilmington and Charlotte) had enjoyed electricity since

almost the turn of the century, an electrical system was still years off for the valley. But mountain folk, being the resourceful people they were, knew the power was flowing right by their doors, so dams and construction of dams sprung up all over the region. Almost anyone who had a large farm or house had a household dam and generator, which provided enough electricity to run a few household appliances and run lights, at least some of the time.

The building of dams brought people to the region to construct them, and in approximately 1936, one team began building a dam on the property of the future Cedar Creek Racquet Club. An old house sat next to the creek, and above that scene pretty little Brenda Sue lived.

Brenda Sue was only fourteen, but with her blond hair, straight teeth and slender build, she was already the buzz in the valley. "She's going to be a looker," many people said. A few times a week, she walked the pig path down from her house, past a few other houses tucked in the holler, to the house beside the creek. There she picked up the mail for her whole little community, and it was there she first caught the eye of two "college" boys.

They were living in the house beside the creek, foremen for the dam building project, and according to local legend, they were either from Charleston, South

This dam brought workers to Cashiers from outside the area, including a couple who were up to no good. *Photo by Kristi Perino.*

Carolina, Augusta or Knoxville. Anyway, they were from "off," and they did not have a good reputation in the town. There was not much entertainment, of course, so they spent most of their time looking for a good bottle of booze—and they loved a good bottle of rum.

One Saturday, it was raining when Brenda Sue went down for the mail. Rain in Cashiers Valley can settle in like a blanket over the land. The clouds laid low on the mountain peaks, and rain pelted the pig path that Brenda Sue trudged. Mud covered the edge of her skirt as she passed her neighbors' houses, and that was the last that anyone saw of her.

When she did not come home that night or the night after, her family became very worried. Search parties were sent out all in the valley, and eventually, people went down to the house to check with the college boys. They were gone, but the search party discovered something even more disturbing—there was a large pool of blood at the bottom of the steps and a trail of it up the stairs. Scattered about lay pieces of a girl's clothing, and when they looked, they knew; it was Brenda Sue's clothing, and suddenly, everyone knew what had happened. The boys had committed foul play, and then fled the region.

There was not much law in Cashiers at that time, but what law was there tried to find the men. The work on the dam stopped and the local men refused

to work for the company, in honor of pretty little Brenda Sue. Finally, the owner of the construction company came into town and visited with Brenda Sue's family deep in the holler. He offered them $1,000 to squelch the situation, and the story goes that they took it and immediately left for Brevard. Thus, the dam was completed and electricity came to that little holler, but the body of Brenda Sue was never recovered.

In 1978, William McKee and Howard Riley purchased the property and hired Jim Monteith to help turn the private residence into a tennis facility. Monteith cut the locks that were put on the house by the creek in 1936, and walked inside. While not the only structure on the property at the time, the house was the only one that had not been examined for a new use. He relates what happened next:

> *There was an old newspaper dated 1936, wish I'd kept it, and old woodstove in there, a very old house. The place hadn't been cleaned up, and there was evidence of mice, and papers still piled in the trash. There was a half-opened jar of jelly, and really, it just looked like someone had left in a hurry.*
>
> *At the bottom of the stairs, there were great big stains and stains on the stairs. I did not put two and two together and thought someone had spilled something.*

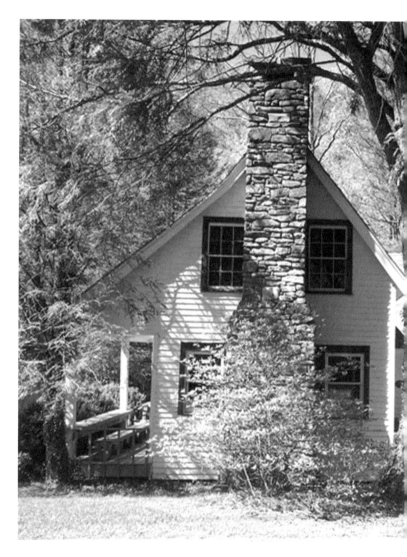

This home, now part of the Cedar Creek Racquet Club, had a blood-soaked stairway when pretty little Brenda Sue went missing. *Photo by Kristi Perino.*

> *Every room had a fireplace, and upstairs there was*
> *a chest of drawers and a chifforobe. In that chifforobe*
> *was a bottle of Mt. Gay rum, two-thirds full. It was a*
> *greenish bottle and had a cork in it.*

Monteith took out the rum, since he liked rum, and later he invited William McKee to bring some Sealtest orange juice back to the house and drink it. They did and did not think another thing about it.

Since he was hired to revamp the old place, he called a floor refinisher to clean up the stains. The dark stains went all the way through the wood, so they had to replace it. When Monteith arrived back at the house, he noticed that the stains were still there—they had returned, in just the same spots they had been before.

There was already another building on the property at this time, and Monteith hired a bright young woman to oversee the large project and thus live on-site in the building a short distance away from the old house with the odd stains. From the first night she stayed in the building, strange things happened starting at around 11:00 p.m. Toilets flushed, doors opened and closed, and her cat, Buckwheat, bristled and seemed to watch someone walk down the hall. It was enough for her to complain to Monteith, who admits that he never thought anything about it. After about two weeks, the site manager could no longer take the nightly ramblings

of an unseen force—she moved out since "she hadn't had a good night's sleep."

Things were moving along at the newly formed Cedar Creek Racquet Club, and Monteith was often forced to work late in the same building that had already scared off one site manager. Still, he felt comfortable in the place, that is until toilets began flushing and doors opening. The phone would ring three times, and each time there would be no one on the other end. And then there were the bottles of rum.

One Monday morning, he came to the office to find all the windows open in the building and, strangely enough, a couple of bottles of Mt. Gay Rum (from a cabinet) sitting out in the middle of the hallway. Thinking that William McKee had had a party the night before, he called him to ask, but McKee denied it. There had been no one in the building since Monteith vacated it the afternoon before. Yet another time he entered the office to find a bottle of rum sitting on the counter. It was then he got the idea to name the bathtub regatta at the club the Mt. Gay Regatta, and thus it has remained so named ever since.

The day they named the regatta was the day all activity in the house stopped. Quiet as a pin.

Monteith believes that it was Brenda Sue saying she had gotten her revenge on the college boys through rum tainted with wood alcohol. But whatever it was,

there is no doubt that it was connected to the rum. It is quite probable that McKee and Monteith consumed the same bottle of rum the murderers did on the day pretty little Brenda Sue died.

CASHIERS GENERAL STORE
An Escalation of Ghostly Activity

The town of Cashiers pretty much sits at the intersection of Highway 64 and Highway 107, and 25 Burns Street sits right in the middle of all the activity. Today it is the site of the Cashiers General Store, a place that houses antiques, gifts, flowers and even candles scented like a Thanksgiving kitchen. People wander in and out, and during the busy summer months, sometimes fill the rooms of the shop with chatting and laughing.

However, there are some parts of the store that customers never see—dusty rooms that hold stock, a room partitioned off by a curtain and narrow steps—steps so narrow that they are dangerous—that lead to a dark and claustrophobic attic. The attic is used for storage as well, but still smells dusty and old, like attics of old houses always do, beams exposed and the roof closing in on the space. It is a space of another time.

The Cashiers General Store was once a residence and may still house a presence that doesn't want to leave. *Photo courtesy of the Cashiers General Store.*

The Cashiers General Store was not always a place of business. It was once a family home, with a front parlor, kitchen, downstairs bedroom and bedroom upstairs. There was even a pallet upstairs in that dark attic, and the house was filled with a succession of families over the years.

One of those families was the family of David Watson, who invited his mother, Mary Lou Watson, to live with him in the late '60s. She ran Tommy's Restaurant, just steps from the front door of the house

on Burns Street. The Watson family moved out for the winter, and Mary Lou moved into the house with all the rooms closed off except her bedroom, the kitchen and the den.

She didn't think much about it; she really only intended to sleep there since she was managing Tommy's most of the time. Tommy's, a Cashiers establishment, still sits on Highway 107 today, serving up family-style meals just like it has for years. It is the type of place where you know the waitress and the cook by name and where you're just as likely to hear the latest local gossip as to get a good cup of black coffee.

Mary Lou fit right into this atmosphere, and she worked hard to try to keep the restaurant going, so it was no surprise that when she walked the few yards to the house on Burns Street, she was looking to unwind for a while and then retire for the evening in her cozy bedroom. However, as soon as she moved in, the first night she heard moaning sounds, moaning and groaning that seemed to come from the upstairs bedrooms and emanating down those narrow, narrow stairs. In her unpublished memoirs, provided by her daughter Robin, she recalls how she explained it all away:

> *I wasn't frightened because my son had told me the house was drafty, and I thought the wind was causing the racket. Had I used a little common sense, I would*

have known that no draft could cause that occasional shriek that I heard. That sounded as though someone had stepped on a cat's tail. This happened just about every evening around eight or nine o'clock.

For some reason she wasn't frightened. Maybe it was those long hours on her feet at the restaurant or her calm disposition, but whatever it was, the moans seemed to go on every night, and Mary Lou went right on to bed, explaining to herself it was just the wind— until one night a visitor heard the noises.

Her son-in-law, Odell Hunter, came to the restaurant just as Mary Lou was closing up, and he insisted on taking her home although it was just a short walk. When she got home,

the house was nice and warm, and everything seemed fine as we sat chatting a bit. Then the moaning started up, not so loud as usual, but suddenly, there came that loud screech. Odell jumped to his feet, a very funny look on his face.

"What in the world was that?" he asked.

I told him I heard that every evening; it was only the wind.

"That was no wind," he replied. "That sounded like a dying dog. I'm going up there and see if I can find what ever it is."

He went upstairs and I could hear him moving about. After a few minutes he came back down and told me there was nothing up there, every thing was in order. The windows were tightly closed; there was no way the wind could make that noise; besides it wasn't blowing.

He left soon after that saying, "You couldn't hire me to spend the night alone in this house, for love nor money."

Although she loved her son-in-law, his words did not seem to scare her. She had always felt comfortable in that house, even on the cold nights when the wind whipped off of Whiteside Mountain and flew into the valley on a mission. But although she felt comfortable, she didn't always sleep well.

One night, after she crawled under the sheets and was beginning to drift off to sleep, the sounds of a party in the rooms outside her closed bedroom door woke her. Hating to crawl out of the warm bed, she lay awake and listened for a moment until she was sure of what she heard. Then she slid out of bed and opened a door to an abrupt silence, only a clock ticking and the sound of the refrigerator cycling on. She stood there a moment, her figure silhouetted in the open door, and heard nothing. Thinking that she must have been dreaming, she crawled back into bed, only to hear the sounds of a party start up once again, voices talking, a

woman laughing, but just out of earshot, just to where she could not decipher the words.

It happened twice more, the sounds of a party and then silence when she opened the door. Finally she had had enough.

> *I hopped out of bed, no longer trying to keep it quiet. I went straight to the living room door and opened it. I stuck my head into the room and said loudly, "Will you all be quiet so I can get some sleep! I have to get up early and go to work."*
>
> *With that I closed the door and went back to bed. I lay there and waited for the party to start up again, but there was total silence. I waited and waited, but there was never a sound from the living room. I drifted off to sleep feeling kind of funny; whoever heard of telling ghosts to be quiet.*

Although she might not have seen anyone when she opened the living room door that night, there was no doubt that things seemed to be escalating in the house. First moans and shrieks upstairs, then sounds of an intense party in full swing on the ground floor. It was only a matter of time until whatever was in that house wanted to get Mary Lou's full personal attention.

It did not matter that her son and his family had returned, filling the house with the sound of boys

playing and the bustling of packing lunches for another day at school. Mary Lou did not pay much attention to the strange sounds of the house—but she still heard them.

One night, after the house settled down, and the whole family went to sleep, Mary Lou was again unable to ignore the sounds. Although the family had returned, she still occupied the downstairs bedroom, and in the middle of the night, she awakened to the sound of someone moving about her room. She knew someone was there, but in her groggy state could not seem to figure out why her daughter-in-law would be looking for something in her room in the middle of the night. She noticed that everything was illuminated decently by the streetlight outside her window, but she thought, if her daughter-in-law just had to look for something, she might as well turn on the light, and she sat up in her bed to tell her so.

> *I sat up in bed and opened my mouth to ask why she didn't turn the light on, and stared in astonishment. Standing at the foot of my bed was a female. I have always thought of her as a little old lady, but she could have been just a girl, as I didn't see her face.*
>
> *She was dressed in a filmy gray long cape and a cap with a drawstring tied under her chin, like a little red riding hood outfit.*

I stared at her for some seconds and had almost picked up nerve enough to ask what she wanted, when she gradually began to fade away. One second I was staring at a being, the next at an empty space.

I wasn't frightened, nor had I been during the time I lived in that house. I simply lay back and went to sleep.

At that time, Mary Lou left the house for a while and went to visit her daughter. Two months passed before she spent another night in the house. She missed her grandsons and they missed her, so her son and his family once again got Grandma's room ready for her, and she walked up the short steps to the door.

Although the family went to sleep at their regular time, Mary Lou wanted to relax some more before turning in, and she decided to stay up and look through some entertainment magazines. She spread them out on the kitchen table, and after settling into her chair, soon got engrossed in the workings of Hollywood, all the while sitting far away from the excitement in the little mountain home.

It had been good to catch up that day with the family, and she felt good to be back in the house again. But although she had never felt scared in the home, all of that was about to change. Right in the kitchen with her, she began to hear a sound, a sound that came from

behind her. It sounded like a piece of paper was being blown about the room, or, more alarmingly, a long-tailed dress was sweeping the floor as someone walked back and forth behind her, pacing.

Suddenly Hollywood seemed as far away as it was from the little kitchen, and Mary Lou was back in the here and now. She abruptly stood up and looked about for something that could be making the noise, but of course she found nothing. Because she had experienced strange things in this house before, she decided to go back to the table and her reading.

> *I went back to my reading and tried to concentrate on the magazine, ignoring the noise behind me. I had the feeling that someone was staring at my back, so I kept swiveling my head around to look, but of course, there was nothing.*
>
> *I kept trying to convince myself there was nothing there, that I was working up a good case of nerves. So I just went back to my reading. This went on for perhaps an hour, and I finally got to the point of believing it was only a case of nerves, but I still felt uneasy.*
>
> *Suddenly a presence stepped up to my left side and laid a hand on my shoulder. The hair on the back of my neck literally stood up, like the bristles of an angry dog. Goose bumps spread out my shoulders and down my spine.*

I literally panicked; I had never been so scared in my life. I leapt up and went running through the house, turning lights on as I went. I finally settled down well enough to go back and turn the kitchen light out. All was quiet and peaceful.

Mary Lou never spent another night in that house, and years later, her son sold it. They were the last family to live in the structure as a family home, and now, only the days bring people, leaving the woman in a cape to peruse the store's findings after the last customer leaves for the day.

Bibliography

Carden, Gary. "The Cherokee Legend of Spearfinger." Manataka American Indian Council. www.manataka.org/page261.html. Accessed April 5, 2007.

———. "Tuckasegee Tales." *Sylva Herald* 80, no. 4, April 21, 2005.

Dunlop, Kathy. "Town History." www.townoforchid.com/about.htm. Accessed March 24, 2007.

Fichter, Lynn S., and Steve J. Baedke. "Mountain Building Models." The Geological Evolution of Virginia and the Mid-Atlantic Region. csmres.jmu.edu/geollab/vageol/vahist/mtnmodel.html. Accessed April 28, 2007.

Gore, Dr. H. Larry, June Humprey, and Carol Kennedy, et al., eds. *The Cashiers Area: Yesterday, Today and Forever.* Dallas: Taylor Publishing, 1994.

"The Great Floridians 2000 Program." www.flheritage.com/services/sites/floridians. Accessed 24 March 2007.

Bibliography

"How Electricity Came to Western North Carolina." Blue Ridge Electric's History. www.blueridgeemc.com/history.htm. Accessed April 29, 2007.

Middleton, T. Walter. *Trouble at the Forks.* Alexander, NC: Land of the Sky Books, 2006.

Monteith, Jim. "Tale of Brenda Sue." Recorded oral history. April 2007.

Rankin, J. Scott, MD. "William Stewart Halsted: A Lecture by Dr. Peter D. Olch." *Annals Of Surgery* 243 (March 2006): 418–425.

Shaffner, Randolph P. *Heart of the Blue Ridge: Highlands, North Carolina.* Highlands, NC: Faraway Publishing, 2004.

Tinsley, Jim Bob. *Land of Waterfalls, Transylvania Co., North Carolina.* Kingsport, TN: Kingsport Press, 1988.

Watson, Mary L. "Grandmother's Ghost Stories." Personal journal, provided to the author by Watson's daughter, Robin Burton.

Zahner, Robert. *The Mountain at the End of the Trail: A History of Whiteside Mountain.* Illustrations by Sid Jackson. Highlands, NC: R. Zahner, 1994.